Oil Painting

WITH WILLIAM F. POWELL AND MIA TAVONATTI

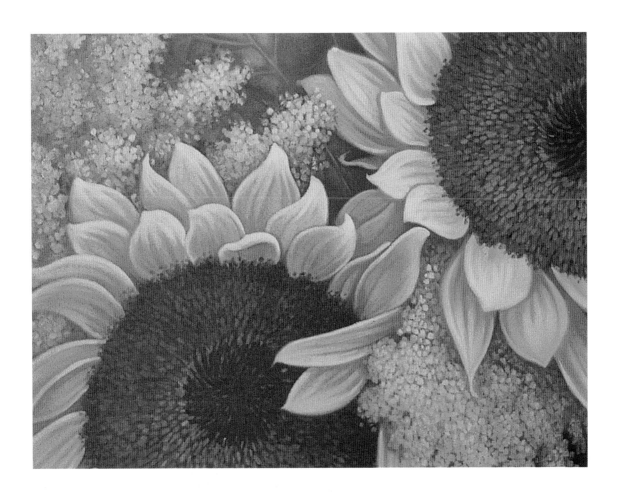

Walter Foster REEVES
SINCE 1766

Contents

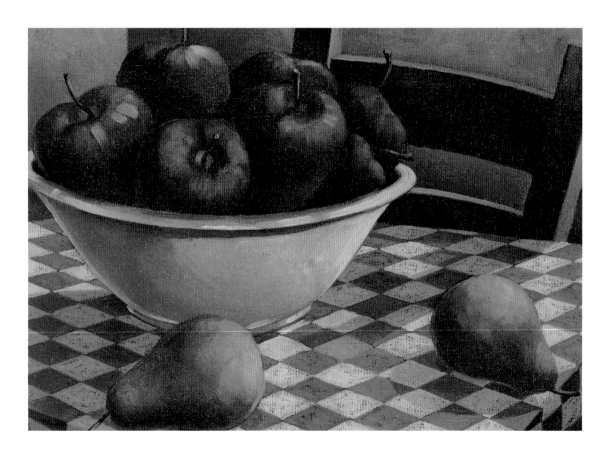

Introduction

The beauty and versatility of oil painting have captivated artists for centuries. Today the high-quality oil paints available are a result of extensive research and practical experimentation.

Now anyone can go to an art store and purchase ready-made oil colors, but a long time ago artists had to find pigments from nature, such as clay, roots, and berries, and grind them into powder. The powdered color was then combined with a drying vegetable oil and used as finished oil paint. It wasn't until 15th-century Europe that the use of oil-based color became increasingly popular with artists such as Raphael and Titian. Over the years, many improvements have been made, and oil paint has continued to be an incredibly popular medium.

Modern oil paints have evolved into powdered pigments combined with a drying oil, such as linseed, safflower, or nut. This oil additive has a number of functions: (1) it protects the pigment from moisture and harmful particles, (2) it allows the pigment to flow evenly, (3) it adheres the pigment to the surface yet keeps it pliant, (4) it enhances the depth and tone of the color, and (5) it helps prevent the pigment from becoming brittle with age.

Although there are many approaches to oil painting, the most common approach is to sketch the drawing on the painting surface first. This initial sketch can be done with thinned oil paint, watercolor, or a drawing tool such as charcoal, carbon, or pencil. After blocking in the subject, some artists apply a thin undercolor over the drawing to set the color scheme.

Once all the preliminary work is done, the actual painting begins. Oil paint is well-suited to a variety of painting styles, from extremely detailed, photorealistic work to loose, colorful impressionistic paintings. And oil is an incredibly forgiving and versatile medium—its slow drying time and rich colors make it a perfect medium for beginning artists.

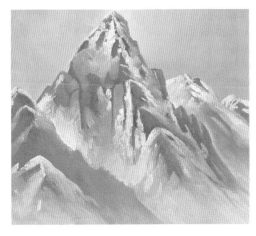

You'll find lessons in the book from two artists who each use a distinctive approach to oil painting. The differences in their approaches demonstrate some of the various methods and processes of creating an oil painting from start to finish. Follow along with each exercise closely, and then experiment with the approaches and techniques you've learned on your own. We hope you will enjoy this book and find it a source of guidance and inspiration as you explore the art of oil painting.

Tools and Materials

Oil Paints

You don't need to purchase every color you see; you can mix just about any color you wish from just a few basic colors. In this book, all of the projects were completed with a limited palette of six colors. (See page 5 for more on working with a limited palette.) But Reeves packages oil colors in convenient sets that provide all the colors you will need.

Mediums

Oil mediums are used to alter the consistency of oil paints—to thin the paint when it gets dry and stiff and for glazing and underpainting. A variety of mediums are available to oil painters; some help speed the drying time, while others add a glossier finish to the paint or help preserve the pigment and keep it from cracking with age. Linseed oil is a popular choice; it helps create a buttery consistency in your paint, and it is helpful for thinning out paint when building up layers of color.

Brushes

Oil painting brushes can vary greatly in size, shape, and texture; Reeves manufactures a variety of brushes to choose from. Soft-hair flats can be used to create soft, blended strokes. Soft-hair rounds hold a point, and they allow you to vary the widths of your strokes. Brights have shorter bristles, making them good for more aggressive brushwork. Stiff, bristle-hair filberts are flat brushes with slightly rounded tips and are good for applying a lot of paint and for creating texture. Small liner brushes are well-suited to fine detail work, and a fan brush is designed for glazing with thin paint or creating soft blends.

SUPPLIES Since 1766, Reeves has been manufacturing excellent-quality paints and brushes and has long been established around the world as a wonderful source of art material for beginners. Reeves paints and brushes are available at art supply stores everywhere.

Brush Care

It's important to clean your brushes thoroughly after each painting session. If the paint sits in the brushes for an extended period of time, the bristles become damaged and cannot be restored to their original condition. First clean your brushes with thinner (such as turpentine or mineral spirits). Then squeeze the brushes dry with a cloth rag or paper towels; when no more color runs from the brushes, wash them several times with soap and lukewarm water. Then reshape the bristles with your fingers and lay the brushes flat to dry; store them bristle-side up.

Palettes and Palette Knives

Palettes are used for laying out paint and mixing colors. They're available in various shapes, sizes, and materials—from ceramic and plastic to metal and glass. Whatever palette you choose, just make sure it's easy to clean and large enough for mixing colors. Palette and painting knives can be used either to mix paint on your palette or as tools for applying paint to your canvas. Painting knives have a smaller, diamond-shaped head, while palette (mixing) knives have longer, more rectangular blades.

Painting Surfaces

The surface you paint on is called the "support." Canvas is probably the most common surface for oil paints. You can stretch canvas yourself, but it's simpler to purchase prestretched, preprimed canvas (stapled to a frame) or canvas board (canvas glued to a cardboard) in standard sizes. The texture of canvas—called the "tooth"—can range from a smooth, dense weave to a rougher, loose weave. But you don't need to limit yourself to painting on canvas. Other materials can be used as supports, but some may need some preparation (see "Priming Your Support" on page 5).

Using a Limited Palette

A limited palette is one that contains a simple, uncomplicated combination of paints. With a basic palette, you can learn to mix a variety of colors without muddying the entire mix. Although you can add other colors to your palette, using too many colors can make your mixtures confusing, jarring, or dulled. Before starting the exercises in this book, test the suggested colors on a separate sheet of paper to become acquainted with their characteristics. Keep the mixes simple and try not to overblend. When colors are overblended, they lose their lively look and appear less chromatic. When blending or mixing a small amount of color with a brush, always use the tip and do not press down hard into the mix. This prevents the color from riding up into the brush and losing the mix. If you need to mix a larger pile of paint, use a palette knife.

BASIC PALETTE The suggested paints for the projects in this book are burnt umber, crimson, lemon yellow, phthalocyanine (phthalo) blue, ultramarine blue, and titanium white.

Priming Your Support

You can apply oil paint to just about any kind of support—canvas, glass, wood, cardboard, paper, even metal. You just need to apply a primer to give the oils something to stick to and to prevent the paint from shrinking, peeling, or cracking. Most oil painting supports are preprimed and ready to use, but it is easy to prime your own supports. Gesso—a polymer product with the same base ingredients as acrylic paint—is a great coating material because it primes and seals at once. It's also fast-drying and is available at any art supply store. Use a standard 1/8" pressed-wood panel from the lumber store, and sandpaper its surface until the shine is gone. Then apply two or three coats of gesso, sanding the surface in between coats and using both horizontal and vertical strokes for even coverage and to give the surface some texture.

BUILDING AN OIL PAINTING There are several basic elements—or layers—to creating an oil painting. The layers include: (1) the support—the actual material that the painting is made on; (2) the ground—an enhancer between the paint and the support to ensure the paint adheres well; (3) the primer—a thin layer of paint that is applied to assist the bonding of the actual painting to the support and the ground; (4) the actual layers of paint; and (5) the protective coating of varnish.

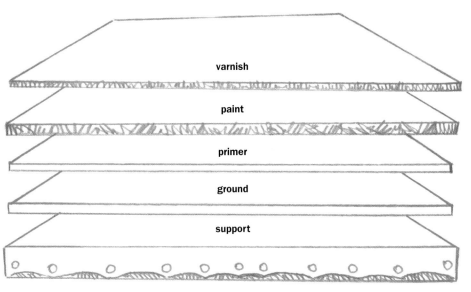

varnish

paint

primer

ground

support

Using Color

Knowing a little about color theory will help you tremendously in mixing colors. All colors are derived from just three *primary* colors—red, yellow, and blue. (The primaries can't be created by mixing other colors.) *Secondary* colors (orange, green, purple) are each a combination of two primaries, and *tertiary* colors (red-orange, red-purple, yellow-orange, yellow-green, blue-green, blue-purple) are the results of mixing a primary with a secondary. *Hue* refers to the color itself, such as red or green, and *intensity* means the strength of a color, from its pure state (straight from the tube) to one that is *grayed* or diluted. *Value* refers to the relative lightness or darkness of a color. (By varying the values of your colors, you can create depth and form in your paintings.) *Complementary* colors are any two colors directly across from each other on the color wheel (such as purple and yellow or orange and blue). When placed next to each another in a painting, complementary colors create lively, exciting contrasts.

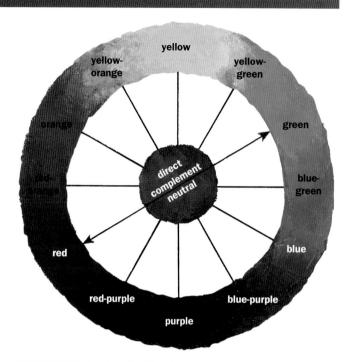

MIXING NEUTRALS There aren't many pure colors in nature, so you have to learn how to neutralize your oil colors. Direct complements can "gray" each other better than any other colors; mixing equal amounts of two complements results in a natural, neutral gray. But there are so many neutrals that you'll need to go beyond using only complements. The chart below shows how to create a range of grays and browns.

COLOR WHEEL A color wheel (or pigment wheel) is a useful reference tool for understanding color relationships. Knowing where each color lies on the wheel makes it easy to understand how colors relate to and react with one another. Whether they're opposite one another or next to one another will determine how they react in a painting—which is an important part of evoking mood in your paintings.

white, red, and greenish-blue	white, red, and purplish-blue	white, yellow, and a variety of purples	white, yellow-green, and warm sienna	white, orange, and warm blue	white, dark brown, and warm blue

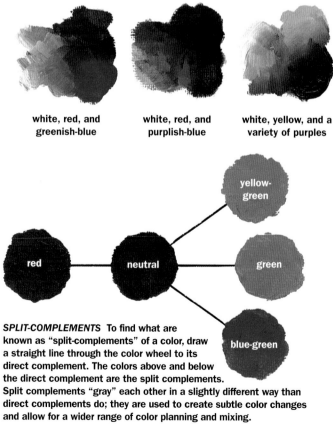

SPLIT-COMPLEMENTS To find what are known as "split-complements" of a color, draw a straight line through the color wheel to its direct complement. The colors above and below the direct complement are the split complements. Split complements "gray" each other in a slightly different way than direct complements do; they are used to create subtle color changes and allow for a wider range of color planning and mixing.

ANALOGOUS COLORS Any three colors adjacent to one another on the color wheel (for example, yellow-orange, yellow, and yellow-green, as shown at right) are analogous. And because analogous colors are similar, they create a sense of unity or color harmony when used together in a painting. For more information about color, refer to *Color and How to Use It* by William F. Powell in Walter Foster's Artist's Library series.

Color Creates Mood

Colors are often discussed in terms of "temperature," but that doesn't refer to actual heat. An easy way to understand color temperature is to think of the color wheel as divided into two halves: The colors on the red side are considered *warm,* while the colors on the blue side are considered *cool.* As such, colors with red or yellow in them appear warmer. For example, if a normally cool color (like green) has more yellow added to it, it will appear warmer; and if a warm color (like red) has a little more blue, it will seem cooler. Temperature also affects the feelings colors arouse: Warm colors generally convey energy and excitement, whereas cooler colors usually evoke peace and calm. This explains why bright reds and yellows are used in many children's play areas and greens and blues are used in schools and hospitals.

NOISE When pure complementary colors are used next to one another, they are loud and unsettling.

MYSTERY Purples and blues can create a mystical, mysterious feeling.

COOLNESS Light, cool colors elicit a calm, serene feeling.

WARMTH Yellows, reds, and oranges suggest warmth.

Painting Techniques

Although a brush is a standard tool for artists, there are many other tools you can use and special effects possible in oil painting. A palette knife, a rag, a sponge, and even your finger can be used to create texture and highlights in a painting.

DEPTH You can create the illusion of atmosphere and depth by adding sky color into the green values of the distant trees. Use loose, softened brush strokes to paint them. For the foreground trees, apply darker mixtures, establishing the general forms first. Then paint details over them, simulating leaf and foliage shapes.

DARK OVER LIGHT This example and the one at right show the same colors on different backgrounds. Colors seem darker on the light background because there is more contrast.

LIGHT OVER DARK Here the same colors used on the left are painted on a darker background. Notice that these colors appear lighter than those in the previous example.

DRYBRUSH This woodgrain effect was created with a drybrush technique. Load a dry brush with thick paint (no paint thinner) and lightly drag it across the canvas to create broken, textured strokes.

THICK PAINT To make this loose blend, load the paint onto the brush and apply it fairly thickly, continuously changing color mixtures and stroke directions. This is a good technique for painting backgrounds.

SAWTOOTH BLEND—STEP ONE For a smooth, even blend, paint two colors next to each other; then use a flat brush to pull the two color together in a zigzag motion.

SAWTOOTH BLEND—STEP TWO After making the sawtooth pattern, move the brush horizontally back and forth to blend the colors evenly. Use this blending technique for large sky and water areas.

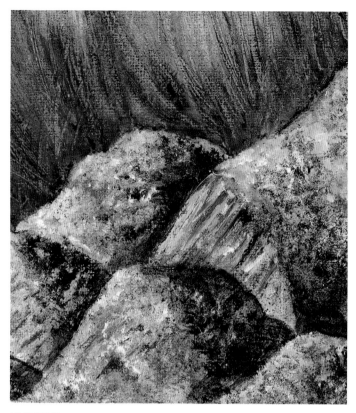

SPONGE Use a sponge to render a rough, mottled texture; here a variety of different colors are sponged on in layers, creating the illusion of granite.

STIPPLE Stippling is useful for rendering shimmering reflections or masses of flowers. Hold a stiff bristle brush very straight, bristle side down. Then dab the color on quickly, creating a series of small dots.

SPATTER Spattering is great for rendering sand or stone. Use a thin, soupy mixture of paint and thinner and an old brush or toothbrush. Load the brush with the mixture; then tap the brush or use your thumb to spray the desired area with spattered paint.

SCUMBLE You can add texture resembling earth to an area by scumbling, or lightly dragging a brush with a little paint on it over an area that's already dry. Don't overdo it; the underlying layer should show through to create a believable texture.

THIN WASH Mixing paint with a little turpentine creates a soupy mixture that you can use to quickly block in large shapes and background areas.

WIPING OUT To lighten a color or to remove excess paint, use a rag, a clean brush, or even your finger to "wipe out" color while the paint is still wet.

SCRAPE Use the side or edge of a palette knife to scrape color away. This will reveal the color underneath, and it is a simple way to depict grains and grasses.

HIGHLIGHTS To create highlights and shadows on mounds of snow, first lay in the blue and purple shadow areas. Then, with the edge of the flat brush, paint the highlights with more pastel mixtures of color.

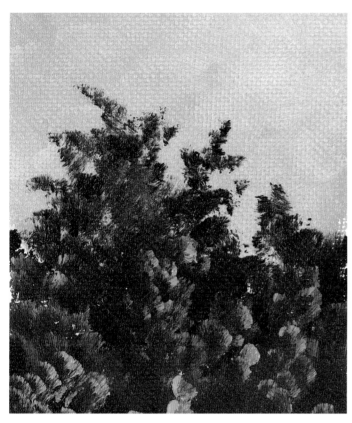

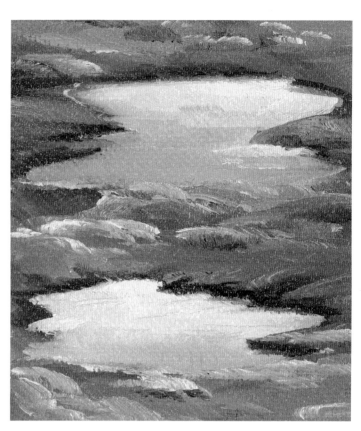

FOLIAGE To create the appearance of bushes and foliage, load a flat brush with paint and gently push it repeatedly in an upward motion. Paint the darker values first; then add the lighter colors.

PUDDLES Puddles in a road or pathway are excellent landscape elements. Use the steps described on pages 20–21 to paint the water and sand.

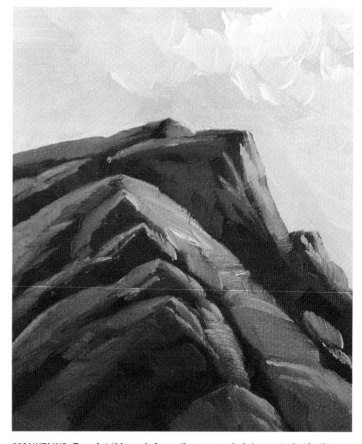

BARK To imitate bark texture, paint the tree trunk with dark brown. Then use white, yellow, and crimson in short, vertical strokes to add the illusion of dappled sunlight.

MOUNTAINS To paint this rock formation, use a dark brown to lay in the overall masses. Mix white, yellow, and crimson to create the rough texture and add highlights.

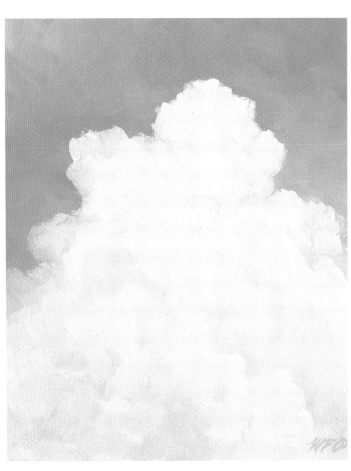

CLOUDS To paint cloud forms, allow some of the background sky color to mix into the shadow areas to create depth. For more information on this subject, refer to *Clouds and Skyscapes* by William F. Powell in Walter Foster's How to Draw and Paint series.

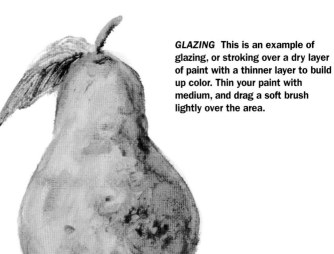

GLAZING This is an example of glazing, or stroking over a dry layer of paint with a thinner layer to build up color. Thin your paint with medium, and drag a soft brush lightly over the area.

DETAILS The point of a round brush can be used to draw details such as leaves, branches, and grasses. For a bushy texture, lay the brush on its side, and use a stamping motion.

13

Lesson One: Mountain Scene

by William F. Powell

This simple mountain scene can be painted with combinations of the basic color mixtures shown below. These mixtures are referred to as mixes #1, #2, #3, and #4 throughout this exercise, and they are the foundation colors for the entire painting. Remember to use white to lighten a mix and more color to deepen it. By planning your palette before you start painting, you'll find that your project develops more smoothly. If you have to stop or take a break before completing a stage of a painting, simply rewet the area with a thin layer of the same color when you return to it.

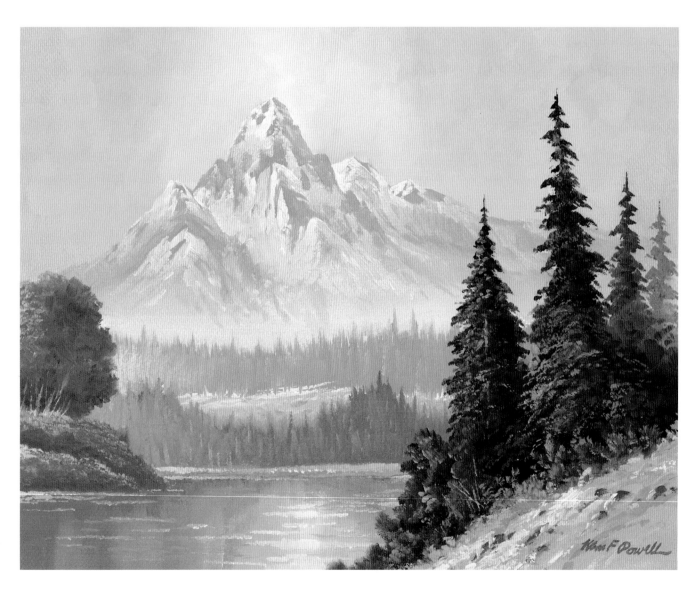

Mix #1:
white + lemon yellow

Mix #2:
white + crimson

Mix #3:
white + ultramarine blue

Mix #4:
2 parts burnt umber +
1 part crimson

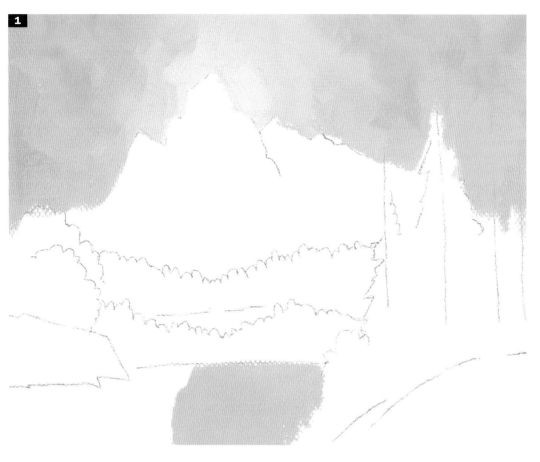

1

STEP ONE Using the mixes shown below, paint the gradual color changes in the sky, keeping the lighter mixture near the top mountain peak to create a sunlit glow. (Keep the paint fairly thin at this point.) Next paint a thin layer of color in the lake to create the appearance of a reflection.

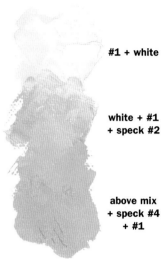

#1 + white

white + #1 + speck #2

above mix + speck #4 + #1

STEP TWO Use the swatches below as a guide for the undercolor on the mountains and the rest of the lake. Use white plus a speck of ultramarine blue for the haze at the bottom of the mountain. Finally, use a clean flat brush to blend the sky, and then blend the colors in the lake using soft, vertical strokes to create more reflections in the water.

2

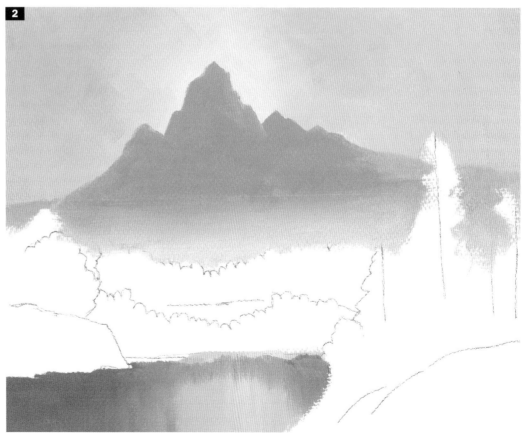

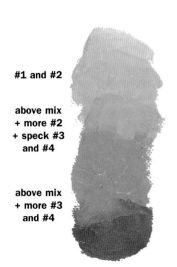

#1 and #2

above mix + more #2 + speck #3 and #4

above mix + more #3 and #4

STEP THREE Notice that the two color swatches below are mixed loosely; you can still see the shades used to mix them and the resulting color isn't completely blended. Use these mixtures to block in the distant shore, middle flat land, and trees. To suggest distant trees, turn a flat brush sideways and use short, vertical strokes. Hold the brush horizontally when painting the shoreline in the distance.

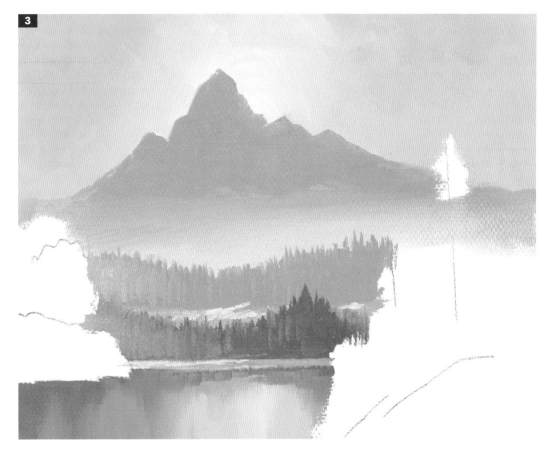

#1 + speck #4

#1 + #2 + #4 and speck #5

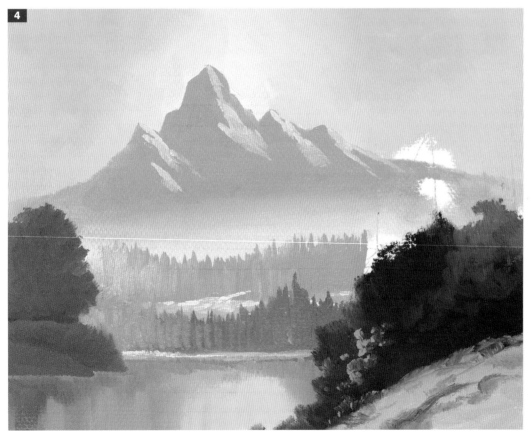

STEP FOUR Next refer to the color samples below and use a flat brush and short, broken strokes to develop the forms of the middle trees, peninsula, and foreground bushes. Use the sky mixes on page 15 for the foreground bank.

white + #4 and #3

#4 (dark) spotted with mixes of #1 and #2

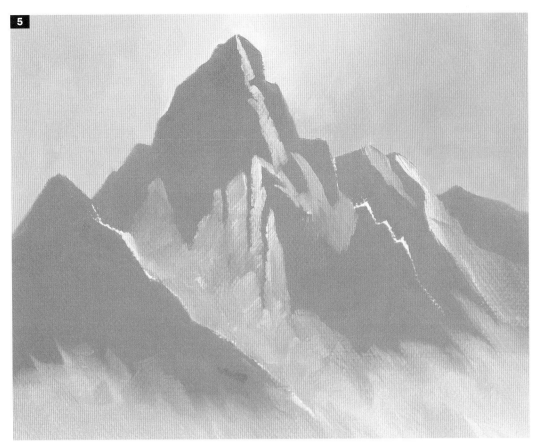

STEP FIVE Now develop the form of the mountain. Referring to the colors below, build from the darkest colors to the lightest colors in gradual stages. Softly blend in the mist at the base of the mountain with a clean, dry brush. Use white mixed with color #1 to paint in the sunlit side of the mountain, and use a mix of white and color #3 for the snow. Try to make all your brush-strokes follow the shape and planes of the mountains.

white +
#3 and
speck #4

white + #1,
#2, and
speck #4

white +
speck #3

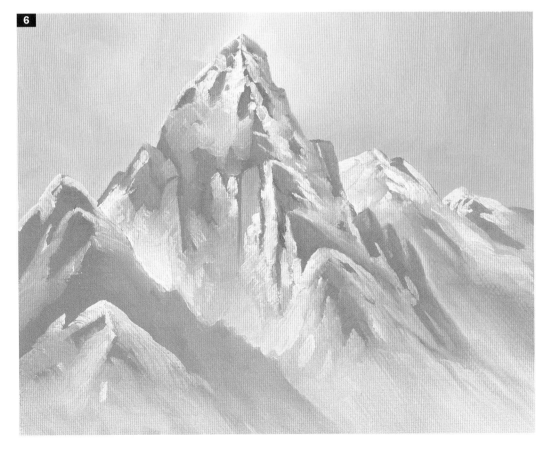

STEP SIX By blending some areas along the mountain and not others, you can create a sense of depth and atmosphere, as well as the illusion of jagged edges and smooth surfaces on the various planes. Wipe your brush clean on a paper towel between each blending stroke to prevent the colors from mixing and becoming muddy. Before placing the final highlights on the sunlit mountains, study the play of light in between the peaks. (See page 14 for the final painting.)

Lesson Two: Snow Scene

by William F. Powell

In this soft winter scene, the artist captures the viewer's interest by using a mixture of muted colors in a subtle, yet dramatic, manner. The undercolors are slightly muted (but not dull), and lighter, fresher mixes of color are painted over them.

Begin with the basic color mixtures shown below; add white to lighten the colors and add pure color to intensify them. Paint the trees in the distant hills with thin vertical, strokes and a flat brush. Then add brighter colors using short, stamping strokes.

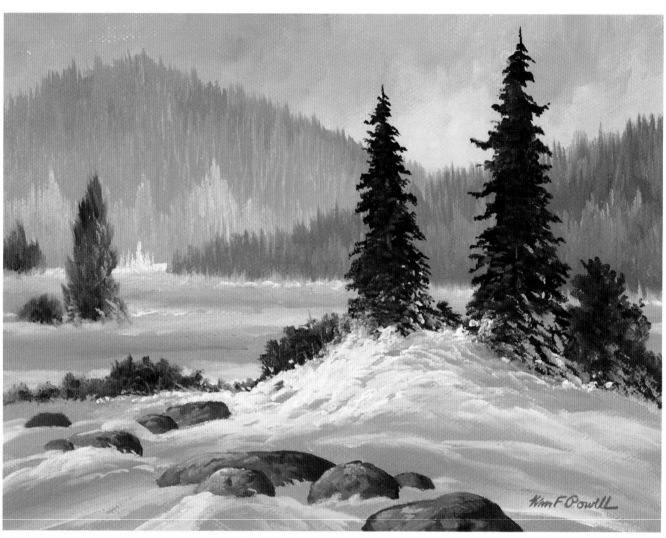

Mix #1:
white +
phthalo blue

Mix #2:
white + ultra-
marine blue

Mix #3:
white +
crimson

Mix #4:
white + burnt
umber and
crimson

Mix #5:
white + lemon
yellow

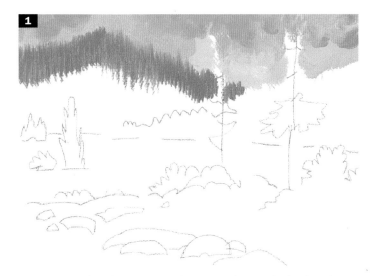

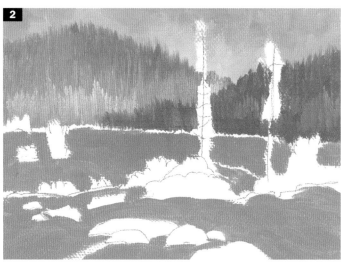

STEP ONE Place the elements in the scene with a simple, thin line drawing. Then use white mixed with color mixes #1, #2, #3, and a speck of #4 to paint the sky; the lightest blues should be along the top of the hills. Begin painting the hills with a mixture of #2, #3, and a bit of #4. Be careful not to use too much of the #4 mix; it is quite strong. If you need to dull the color a bit, you can mix in a touch of burnt umber.

STEP TWO Continue painting the hills in the distance. The light trees at the bottom of the hills should be painted with a combination of white and mix #3. Next cover more of the ground area by painting in a variety of grayed colors; mix white and colors #1, #2, and #3 with a touch of #4. Keep all the mixtures fairly thin at this point, as they are part of the undercolor.

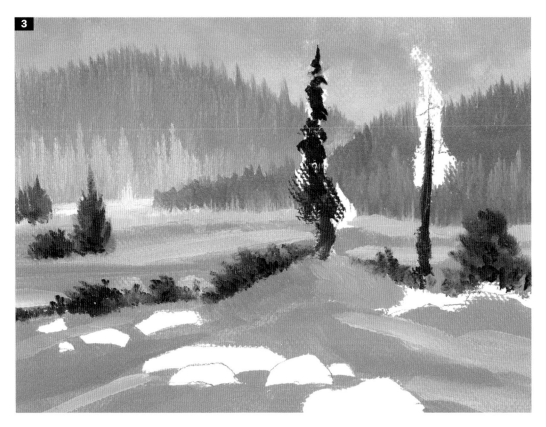

STEP THREE Begin painting the lighter snowbanks using varied mixtures of white, #1, and #2, alternating between the mixtures as you work. Paint the strip of sunlight with white mixed with #5 and #3. Add the dark bushes and trees with color #4 and a flat brush. Darken this color as needed with pure burnt umber, and use this same color for the rocks. Mix a green for the trees with #5 and a speck of phthalo blue. For the darkest trees, add phthalo blue to color #4. Add the final details, referring to the finished painting on page 18 for guidance.

Lesson Three: Seascape

by William F. Powell

The subtle variations in the light and dark values of this seascape make it a dramatic and interesting scene. The softness of evening light is complemented by a multitude of grays created by mixing yellow, red, and blue (shown below) in various combinations. Each hue is muted by its complement to create a brighter neutral; for example, blue and red make purple, which is grayed by adding yellow—purple's complement.

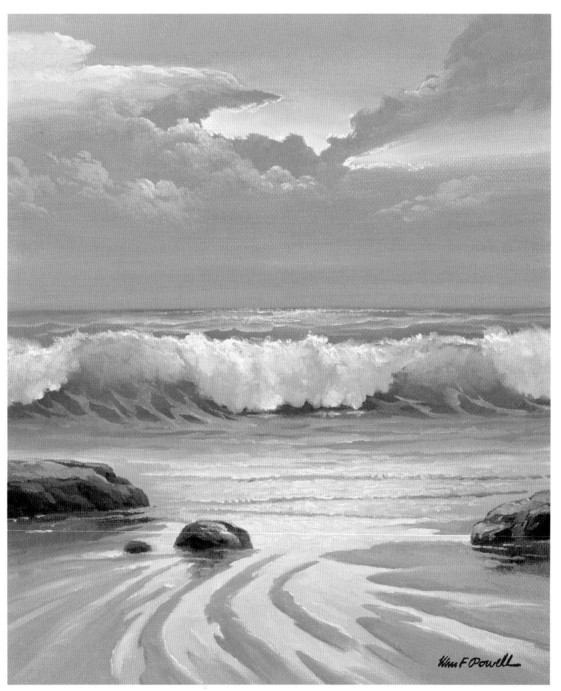

Mix #1:
white + phthalo blue

Mix #2:
white +
ultramarine blue

Mix #3:
white + crimson

Mix #4:
white + burnt umber
and crimson

Mix #5
mix #4 + speck of
ultramarine blue

Mix #5:
white + lemon yellow

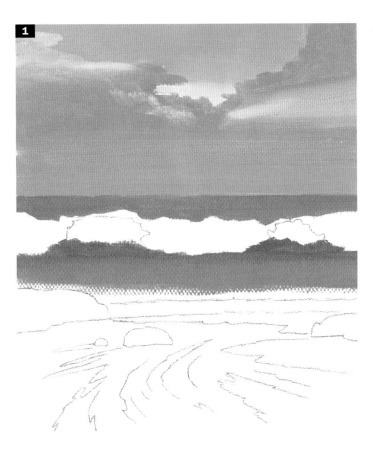

STEP ONE First lightly sketch the scene on your painting surface. Then, using the mixtures shown on page 20, begin painting the glowing light in the sky as well as the cloud formations. Deepen the sky color slightly, and paint in the colors of the backwater, and add a gray color under the wave. Mix a medium value of green by adding a speck of pure yellow to the gray; then paint it into the wave. To make the green deeper, add more blue; to make it lighter, add more yellow. If the green appears too pure and raw, add a touch of mix #4 to mute it slightly.

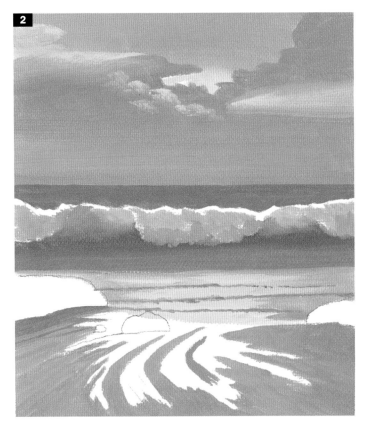

STEP TWO Add a mix of lighter yellow-green to the wave, and block in the foam with white and combinations of mixes #1, #2, and #3. Paint the sand using white with additions of #3 and #5. Mix the sunlit areas with white, #5, and a bit of #4. To make the rocks stand out, paint them using pure burnt umber and mixtures of #5, #3, and #4. Paint in the grooves of water rivulets with white, #5, and a little of #4. Finish the details to your own satisfaction, referring to the final painting on page 20 as a guide.

Lesson Four: Floral

by Mia Tavonatti

Flowers are wonderful subjects for painting—they come in a wide variety of colors and shapes, and they're easy to set up in a still life composition. Sunflowers are especially interesting to paint—they seem so bright and cheerful that their vibrancy can make them appear to leap off the canvas. What makes this particular floral so captivating and realistic is the process of building up the texture of the foliage and background. You'll begin with the darkest values and build up to the highlights (see the color mixing chart on page 25 for all the color mixtures you need for this painting.) To accentuate the bright sunlight in this composition, brilliant highlights of almost pure color are placed on the tops of the petals and leaves to make it seem as if the sun is shining through these flowers from behind.

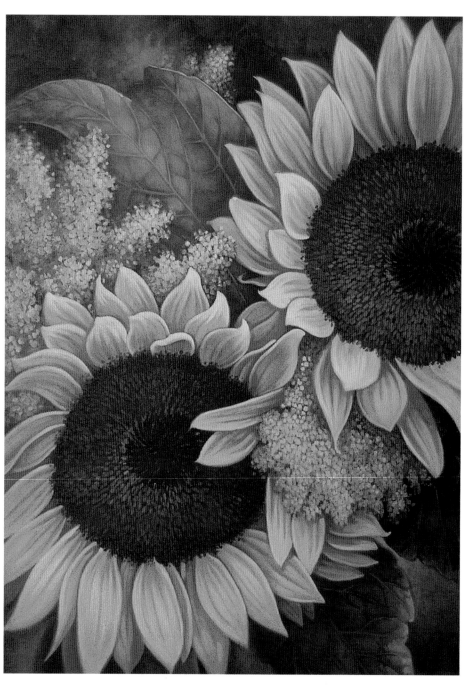

CHOOSING A SUBJECT When you're searching for subjects to paint, it is important to choose images that not only appeal to you but are also visually interesting. These sunflowers make a wonderful scene because the variety of textures among the petals, seeds, and leaves creates visual interest.

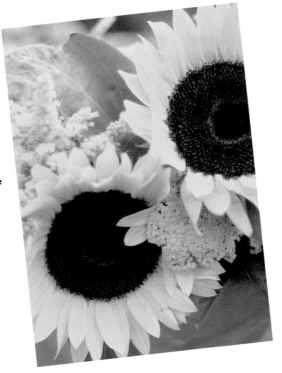

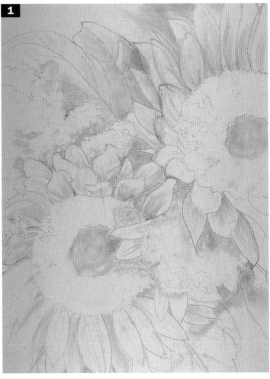

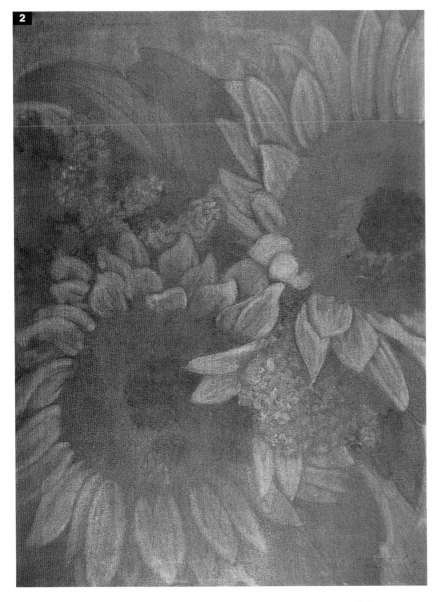

STEP ONE The dramatically close crop of this dynamic composition makes it seem as if you're viewing the sunflowers through a window or camera lens. Notice also that the two main flowers overlap each other, creating a sense of depth in the scene. Sketch in the basic flower and leaf shapes lightly, making sure not to place the main flowers in the dead center of your support.

STEP TWO Before proceeding, secure your sketch on the support by spraying it with a workable fixative or redrawing the lines with a small brush and a soupy mix of burnt umber and turpentine. Once your drawing is dry, tone your support by applying an undercolor. This step is important for several reasons. First, by adding a transparent layer of color over your drawing, you eliminate the stark white canvas that so many artists find jarring. It will also help to unify your palette, since small amounts of this transparent color will shine through everywhere in your painting. Burnt umber is the perfect hue for the undercolor of this floral scene because its red tint will provide a warm backdrop for the other colors. Add some turpentine to burnt umber until the paint becomes thin and very transparent. Apply the mixture with a soft, broad brush and blend it in evenly with a cotton rag, rubbing the color into the support. For the lightest areas of the composition, use the rag to wipe some color off the support.

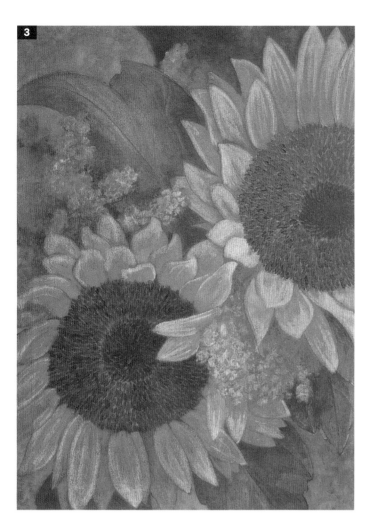

STEP THREE Once your toned canvas is dry, you can begin to establish the darkest areas of the composition. Start by painting in the shadowed areas with the same burnt umber mix you used for the underpainting. Next darken the centers of the sunflowers, using pure burnt umber and a small flat brush. Turn the brush on its edge and create short, choppy strokes that resemble the texture of the seeds. Use this same brushstroke with an earthy green mix of yellow and ultramarine blue to block in the smaller blossoms. Mix crimson first with phthalo blue and white and then with ultramarine blue and white to create several different values of purple. Then paint in the background, using a combination of bluish and reddish purples to contrast with the yellows of the flowers.

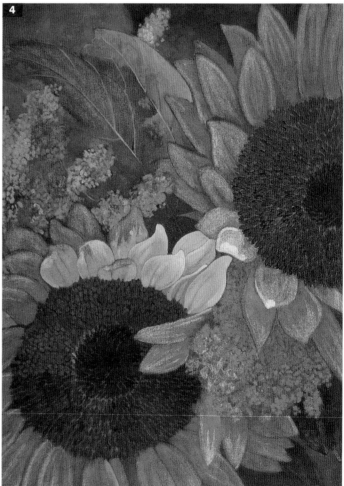

STEP FOUR Before you begin applying color, it's a good idea to try out your color mixes in small amounts on each of the various elements in the painting. Start by experimenting on a petal or two, using a variety of different colors (see chart on page 25). Place the green mixes of yellow and ultramarine blue at the base of the petals and in the shadows. Gradually add orange mixes of yellow and crimson and yellow and burnt umber, blending your strokes outward as you work. Darken the same orange mixes slightly to highlight the seed areas. For the sunlit petals, use your lightest yellow values. Then create several shades of cool greens for the dark shadow areas of the petals using combinations of yellow and phthalo blue. Mix yellow, ultramarine blue, and white for a warm green mix for the brightest areas and highlights of the foliage.

Expanding a Limited Palette

You can mix literally hundreds of colors using a limited palette. Here artist Mia Tavonatti created a variety of hues through simple combinations of color. In each example, the first color listed is shown at the far left, and the last color listed is shown at the far right. The values in the middle of each example are a mixture of all the colors listed. Experimenting with mixing color in this way can be helpful on several levels; it can help you become more familiar with the capabilities of a limited palette, and you may also discover some color mixtures that are compatible for layering.

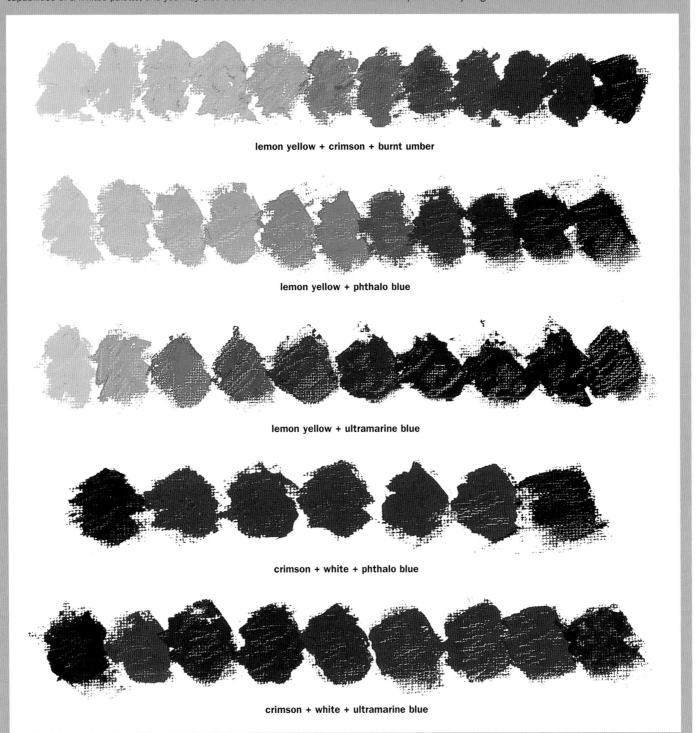

lemon yellow + crimson + burnt umber

lemon yellow + phthalo blue

lemon yellow + ultramarine blue

crimson + white + phthalo blue

crimson + white + ultramarine blue

STEP FIVE Once you're happy with the colors you've mixed, begin blocking in the base colors for the rest of the painting. You're working from dark to light, building up the depth of the flowers and leaves as you go. As you stroke in the petals, blend the colors carefully with a soft brush. Then fill in the leaves with cool green mixtures of yellow, phthalo blue, and white.

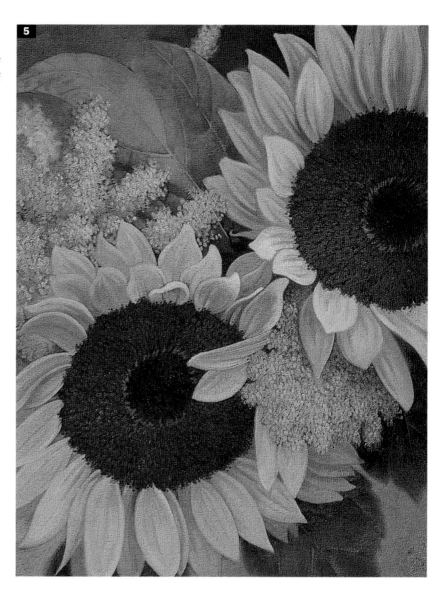

Stippling

For the smaller flowers, try a stippling technique. This technique uses small spots or dots of color, similar to the Impressionist style of *pointilism*. Starting with the darkest value of the yellow flowers, hold a small round brush at a 45° angle, and press small strokes of color onto the support in the shape of the flowers. Mix in more yellow for medium values, and use the same technique to build up the depth in the petals. Don't cover up all of your darkest value; leave some dark strokes showing through for shadows to give the flowers dimension. Finally add even more yellow to the mix for the lightest value and apply even less paint, leaving more of the underlying dark and medium values showing through. Step back often to assess the flowers and adjust the shapes and values as necessary.

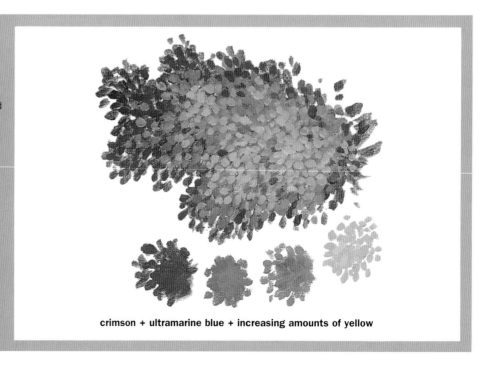

crimson + ultramarine blue + increasing amounts of yellow

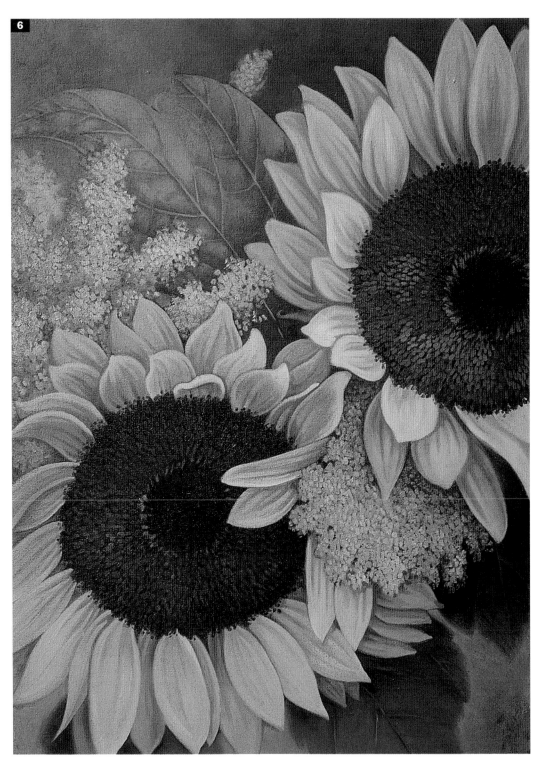

STEP SIX To build up the depth of this scene, you'll need to "push" the shadows (darken them so that they recede further into the distance). When you darken an area of a composition with thin layers of a transparent color, you can make it appear to sink back into the shadows. Mix some burnt umber with a touch of phthalo blue and a little turpentine to create a glaze for the shadows of the seeds. Then mix a dark orange-green using crimson, yellow, and a touch of ultramarine blue to add detail and warmth to the shadows of the leaves. The more orange you add to the green, the more it seems as if the yellow light from the petals is bouncing off the leaves. Finally darken the background and the spaces between the sunflower petals with a reddish purple glaze of ultramarine blue and crimson. You may want to repeat this process to create multiple layers, using light, thin layers of glazes to gradually increase the sense of depth. Make sure to let each layer dry before applying another. Your final task is to "punch up" the lightest areas to make the painting come alive. Refer to the final painting on page 22 as you add bright highlights to the petals and blossoms with a light yellow mixture of yellow and white. To add dimension to the seed areas, mix a bright red-orange with crimson and yellow and create the final highlights.

Lesson Five: Still Life

by Mia Tavonatti

Still lifes are popular subjects because they allow artists to study and develop a variety of skills, such as planning a composition, applying the rules of perspective, and rendering lights and shadows. When you have completed this lesson, try setting up a scene and creating a still life composition of your own. Before you begin, prepare the color mixtures on your painting palette. Arrange the mixtures far enough apart so that they don't bleed into one another. It's also a good idea to keep analogous mixtures near each other; for example, keep all the blues on one side and all the reds on another. The color samples below and at right illustrate the various mixtures used in this painting.

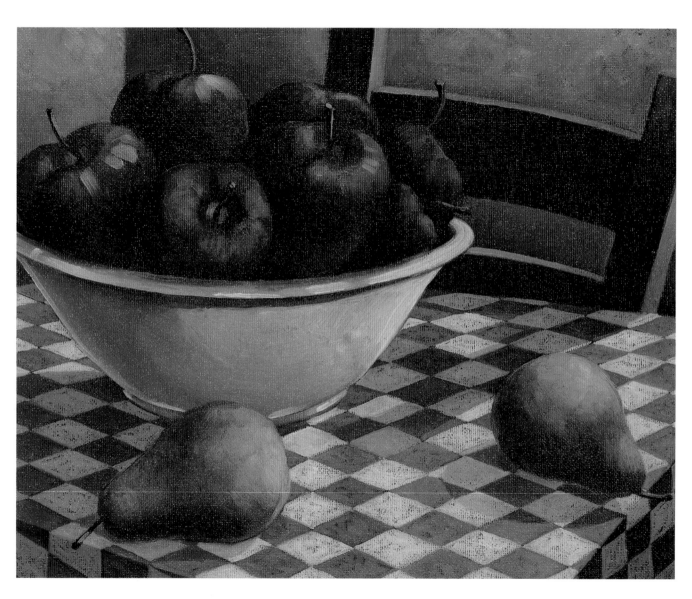

white + lemon yellow + crimson + burnt umber

white + crimson + lemon yellow

white + lemon yellow + crimson

white + lemon yellow + ultramarine blue

white + ultramarine blue

**white + ultramarine blue
+ phthalo blue**

**crimson + lemon yellow
+ ultramarine blue**

crimson + lemon yellow

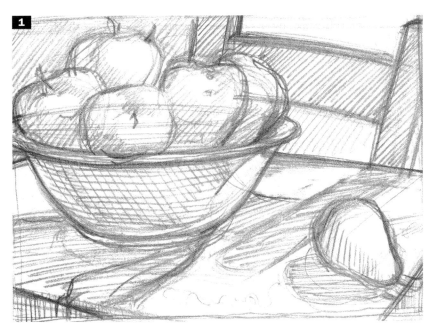

STEP ONE On a piece of paper, use a pencil to draw a small thumbnail sketch of the still life, using a variety of large and small shapes and indicating the placement of the major shadows in the composition. Keep your sketch loose and free at this stage. Also make sure the composition has a good balance of lights and shadows and that it is appealing to the eye. Check that the objects you draw overlap exactly as you see them here, to create the illusion of depth and perspective.

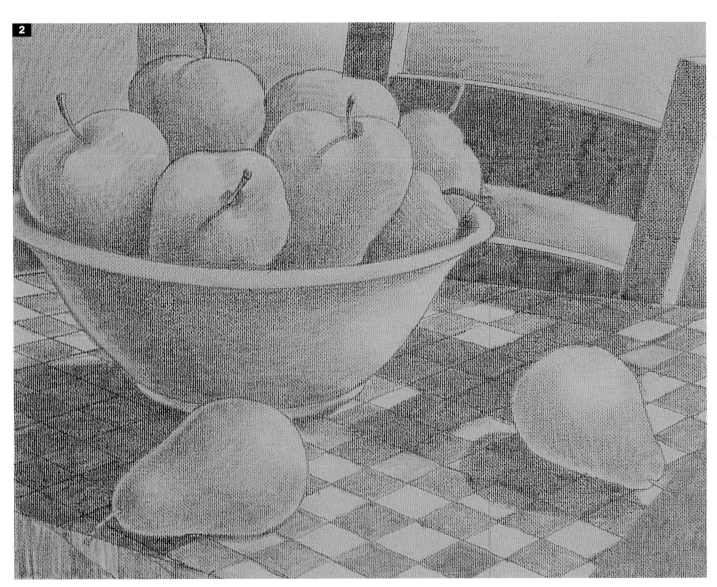

STEP TWO Once the preliminary drawing is correct, sketch the composition onto your canvas with pencil or charcoal. Lightly indicate the shadows from the chair, the fruit bowl, and the pears; these areas will create dramatic value contrasts throughout the painting. Also make certain the edges of the objects are clean and refined; these lines will help guide you while painting.

STEP THREE Next apply an undercolor that will show through the subsequent layers of paint. Mix burnt umber with a small amount of paint thinner so the underpainting will be a thin, transparent layer. Use your flat paintbrush to stain the drawing with the mixture—the stain should be heaviest in the darkest areas of the painting. Once the undercolor has dried, block in the basic colors of the fruit. For the pears, use the mix of ultramarine blue, lemon yellow, and white. For the apples, apply the mix of crimson with a small amount of yellow.

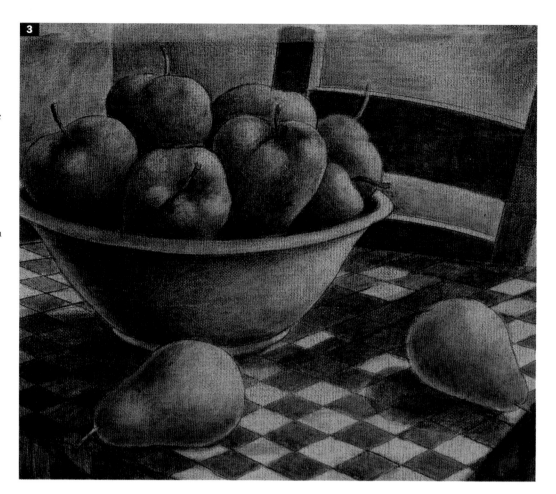

STEP FOUR As you paint, make your brushstrokes consistent with the forms of the objects. For example, the apples are smooth and round, so you should apply curving brush strokes. Paint thinly so that a tinge of the warm undercolor will show through the red values, creating some texture and depth. This effect also gives the painting a sense of realism—a whole spectrum of reds, which can be observed on real apples, is reproduced in your work of art.

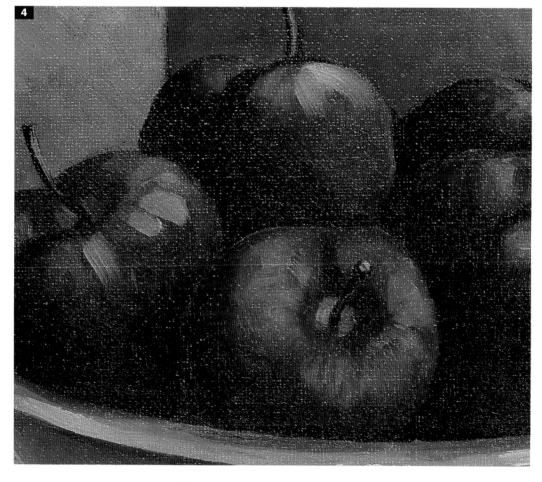

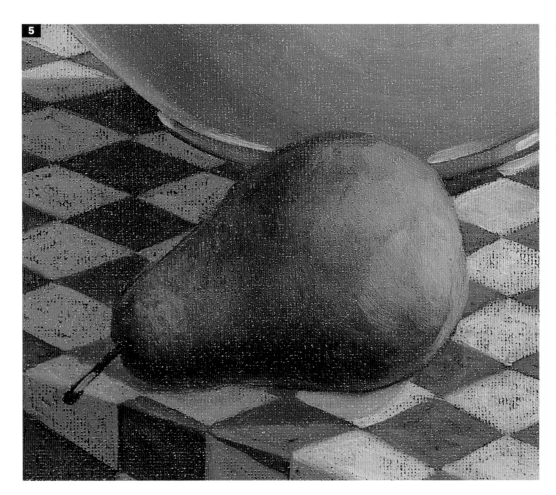

STEP FIVE Note how some edges of the objects are darker in value, giving the illusion that they have rounded surfaces. Make sure the paint color values correspond with the values you see in the example. The darkest reds, for example, should be used inside the top rim of the bowl.

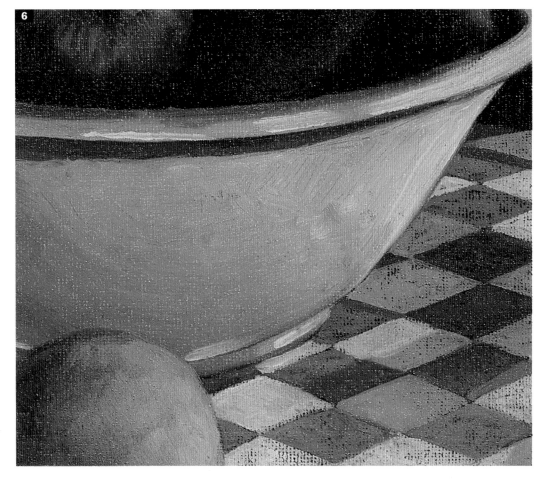

STEP SIX For the final touches, use white with a small amount of burnt umber and lemon yellow to add highlights. The highlights are caused by the light source, which is coming from the upper right of the composition. These highlights enhance the three-dimensional quality and realistic appearance of the objects. Add highlights to the tops of the apples and pears, as well as along the stems of the fruit. Then paint white highlights along the outside and bottom rim of the bowl. Swipe a larger amount of this value onto the tip of a round paintbrush, and apply small blobs of paint without brushing them smoothly onto the canvas. This will give the painting some texture and will lend an artistic quality. (See page 28 for the final painting.)

Conclusion

An artist's skill improves with practice. It is also important to acquire knowledge of other painting materials used with oils.

For instance, using too much oil with a pigment or applying an incorrect varnish can affect not only the life of the painting but also the way that subsequent layers of paint perform with and adhere to the underpaint.

Far too often we concentrate on the "art" of oil painting and forget about both the craftsmanship and the materials used in the process. This does not mean that the art of oil painting must be a long and difficult one. On the contrary, it can be made as simple as the artist wishes. We hope you have enjoyed experimenting with oil painting through the lessons in this book. Remember that practice is the key to success in art. Happy painting!

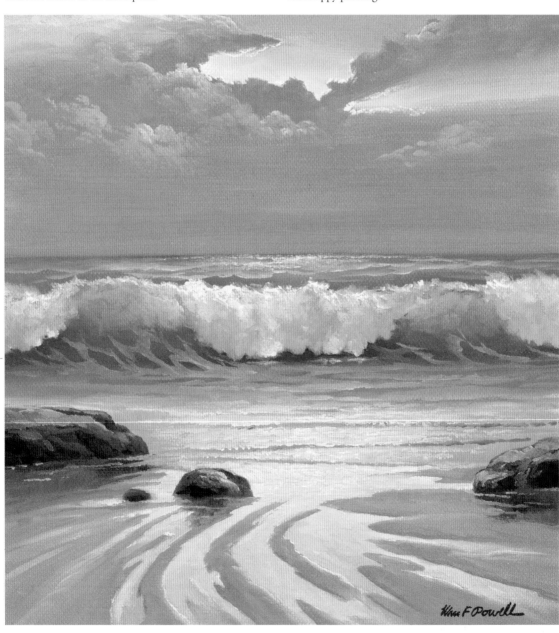